D0597429

Natural Disasters

Estimating

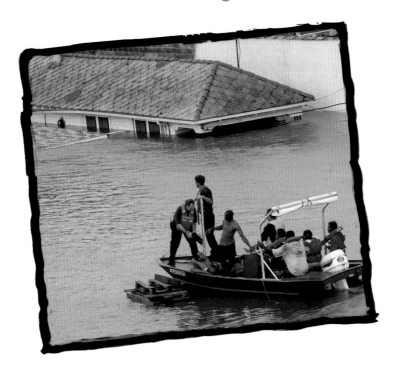

Diana Noonan

Publishing Credits

Editor
Sara Johnson

Editorial Director
Emily R. Smith, M.A.Ed.

Editor-in-Chief
Sharon Coan, M.S.Ed.

Creative Director
Lee Aucoin

Publisher
Rachelle Cracchiolo, M.S.Ed.

Image Credits

The authors and publisher would like to gratefully credit or acknowledge the following for permission to reproduce copyright material: cover NASA; p.1 Getty Images/James Nielsen; p.5 NASA; p.6 Photolibrary.com/Warren Faidley; p.7 Federal Emergency Management Agency; p.8 Getty Images/ Marko Georgiev; p.9 Federal Emergency Management Agency; p.10-11 U.S. Department of Defence; p.12-13 Photolibrary.com; p.14 Photodisc; p.15 iStock Photo; p.16 AAP Image/Paul Hellstern; p.17 AAP Image/J. Pat Carter; p.18-19 Getty Images; p.20-21 Getty Images/Dimas Ardian; p.22 AAP Image/John Russell; p.23 Photolibrary.com/Mark Pearson; p.24 AAP Image/Fadlan Arman Syam; p.26 Photolibrary. com; p.27 Photolibrary.com/Wesley Bocxe; p.28 Getty Images; p.29 Photolibrary.com/Jim Edds.

While every care has been taken to trace and acknowledge copyright, the publishers tender their apologies for any accidental infringement where copyright has proved untraceable. They would be pleased to come to a suitable arrangement with the rightful owner in each case.

Teacher Created Materials

5301 Oceanus Drive
Huntington Beach, CA 92649-1030
http://www.tcmpub.com
ISBN 978-0-7439-0905-1
© 2009 Teacher Created Materials Publishing
Reprinted 2010

Table of Contents

Natural Disasters

Everyone fears **natural disasters**. Luckily, some natural disasters can be **predicted**. When people are ready for them, lives can be saved.

Hurricanes

Hurricanes are strong **tropical** storms. They form over oceans. They **rotate** in a counterclockwise direction.

Hurricane Categories

The strength of a hurricane is rated on a category scale of 1–5.

Category	Wind Speed (miles per hour)	Wind Speed (kilometers per hour)
1	74–95	119–153
2	96–110	154–177
3	111–130	178–209
4	131–155	210–249
5	> 155	> 249

Hurricane Katrina

Hurricane Katrina was one of the worst natural disasters to ever hit the United States. Katrina began as very bad weather on August 23, 2005. It then turned into a tropical storm. Then, on August 29, Hurricane Katrina arrived in New Orleans as a Category 3 hurricane.

Hurricane Katrina in the Gulf of Mexico

A City at Risk

Hurricanes can cause **storm surges**. This is water that is pushed toward the shore by hurricane winds. New Orleans is a city built near the sea. Much of the city is below sea level. **Levees** (LEH-vees) have been built to hold the seawater back.

LET'S EXPLORE MATH

Estimate the average height of the storm surges for these hurricanes. Give the answer in feet and meters.

Hurricane	Category	Year	Height of Storm Surge (approximates)
Katrina	3	2005	29 ft. / 9 m
Opal	3	1995	20 ft. / 6 m
Andrew	4	1992	17 ft. / 5 m
Hugo	5	1989	20 ft. / 6 m
Camille	5	1969	25 ft. / 8 m

Preparing for Katrina

The National Hurricane Center and the National Weather Service had been tracking Hurricane Katrina. On Sunday, August 28, 2005, the New Orleans mayor ordered people to leave the city. Families left their homes in buses and private **vehicles**. About one million people left the city.

But many people stayed. The Louisiana Superdome was opened as a **shelter** for these people. Buses took people to the shelter. Between 20,000–25,000 people stayed at the Superdome.

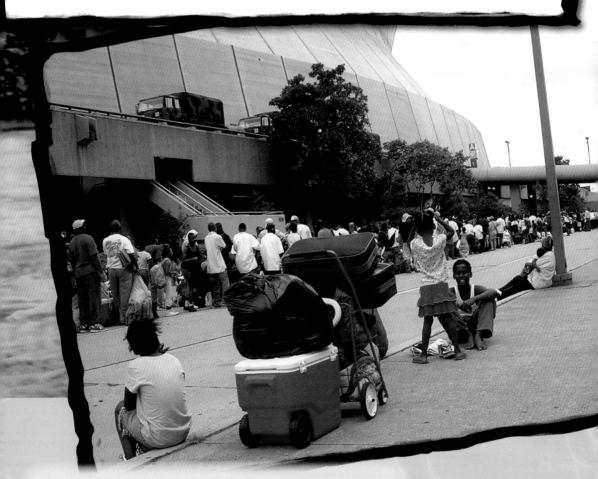

People waited in long lines outside the Superdome.

Relief Workers Ready

The U.S. Federal Government was told that Hurricane Katrina would hit southeastern Louisiana. Search and rescue teams and doctors were ready to help. Water and ice were also ready.

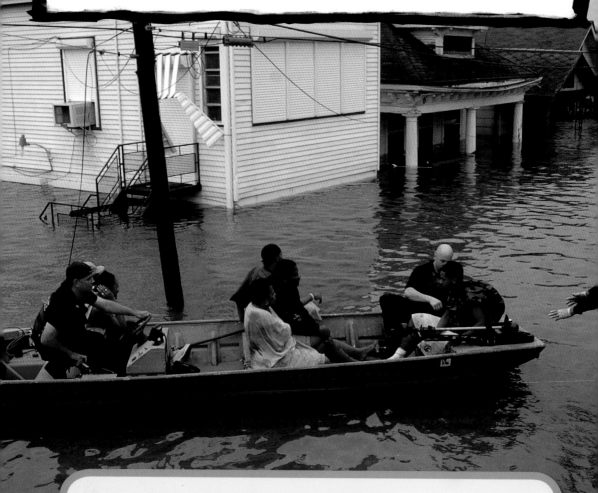

Superdome Predicted to Flood

It was predicted that floodwater would enter the Superdome. People were told to keep out of the Superdome's lower areas.

RUN OR UNLAWFUL TO
THE JOG ON
AND RO

The Hurricane Hits

On Monday, August 29, Hurricane Katrina hit New Orleans. Storm surges broke levees. The city was **severely** flooded. Many people were stuck on the roofs of their houses. Some people were even trapped in their attics.

Power and Water

No clean water was available. The city had no power. It would be weeks before power came on again.

A Damaged City

There was a lot of **damage** to the city. It was hard for doctors and rescue teams to know where help was needed most. Many telephones and cell phones were not working. Roads were destroyed. It was hard to reach people.

The Superdome was also badly damaged. The hurricane ripped two holes in its roof. Floodwaters rose and people had to leave the Superdome. Finally, the whole city was **evacuated**.

Atlantic Hurricanes

Hurricane Katrina formed at sea, in the Atlantic. This table shows the number of Category 3, 4, and 5 hurricanes that have formed in the Atlantic in past years.

Year	Category 3, 4, and 5 Hurricanes
2006	2
2005	7
2004	6

Predictions Do Help!

Although there was a lot of damage, the predictions from the National Hurricane Center and the National Weather Service had helped. The city of New Orleans was warned. People were told to leave. Hundreds of thousands of lives were saved.

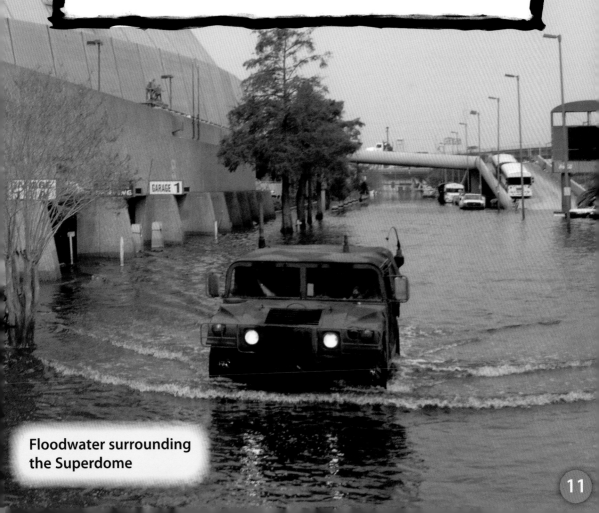

Floodwater surrounding the Superdome

Oklahoma Tornado Strike

Every year, tornadoes can strike with little warning. The high winds damage homes and other buildings. People can be badly hurt. People can even die. On May 3, 1999, Oklahoma had its worst tornado in history.

Tornadoes

Tornadoes are rotating columns of air. They reach down to the ground from thunderstorm clouds.

Tornado Force

The strength of a tornado is rated on a force scale of 0–5.

Force	Wind Speed (miles per hour)	Wind Speed (kilometers per hour)
F0	40–72	64–116
F1	73–112	117–180
F2	113–157	181–253
F3	158–207	254–333
F4	208–260	334–418
F5	> 261	> 419

States at Risk

Tornadoes are more predictable in some places than others. More tornadoes form in the central United States than anywhere else in the world. This area is sometimes called Tornado Alley.

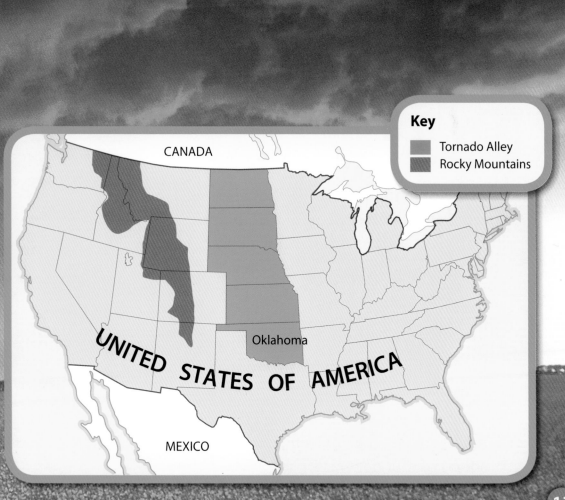

Key
- Tornado Alley
- Rocky Mountains

CANADA

UNITED STATES OF AMERICA

Oklahoma

MEXICO

From Thunderstorms to Tornadoes

Tornadoes begin from thunderstorms. Thunderstorms begin when warm, moist air meets cool, dry air. This forms what **meteorologists** (mee-tee-uh-ROL-uh-jists) call a **front**.

LET'S EXPLORE MATH

You can estimate the distance between yourself and a thunderstorm by counting the number of seconds between a lightning flash and the sound of thunder. Then divide that number by 5 for a distance in miles or by 3 for a distance in kilometers.

a. Estimate the distance in miles if the time between the lightning flash and the sound of thunder was 15 seconds.

b. Estimate the distance in kilometers if the time between the lightning flash and the sound of thunder was 21 seconds.

To turn into a tornado, a thunderstorm has to start rotating. Tornado Alley lies east of the Rocky Mountains. Air coming down off of these mountains is cool and dry. This air starts a thunderstorm rotating.

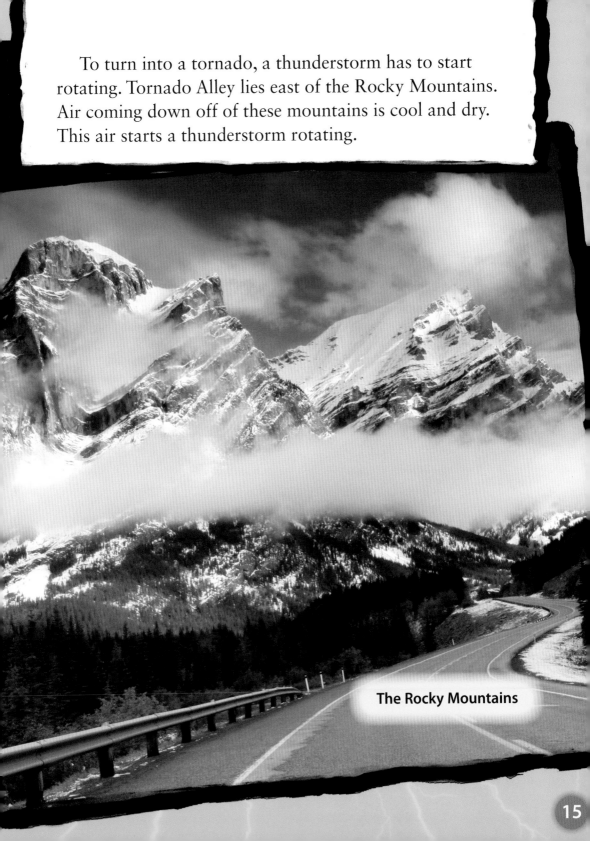

The Rocky Mountains

The Experts Predict

May 3, 1999, was hot and humid in Oklahoma. Meteorologists thought there was only a slight risk of thunderstorms. But, by 4:15 P.M., the first severe thunderstorm warning was made. By 4:47 P.M., the first tornado warning was made. Winds up to 80 miles per hour (129 km/h) were predicted.

Data Helped Predictions

Meteorologists used data from **radar**, **tornado spotters**, and satellite images to track the storms. They even watched the tornadoes on television news.

A Tornado Hits

At around 7:00 P.M. on May 3, the weather service predicted that a large tornado would hit Oklahoma City. People were warned to take shelter or leave the city. At 7:31 P.M., a Force 5 tornado ripped its way through Oklahoma City.

Oklahoma City after the tornado

Destruction

Oklahoma has many tornadoes. But the tornado that swept through the city on May 3, 1999, was incredibly strong. The tornado damaged or destroyed 8,000 buildings in Oklahoma. Forty-two people died.

LET'S EXPLORE MATH

This table shows the number of tornadoes per month in the United States over 3 years.

a. Round each number to the nearest 10.

b. Estimate the total number of tornadoes for each year.

c. How could these numbers help meteorologists predict future tornadoes?

Tornadoes in the United States

Month	2007	2006	2005
January	21	47	33
February	52	12	10
March	171	150	62
April	165	245	132
May	250	139	123
June	128	120	316
July	69	71	138
August	73	80	123
September	51	84	133
October	87	76	18
November	7	42	150
December	19	40	26

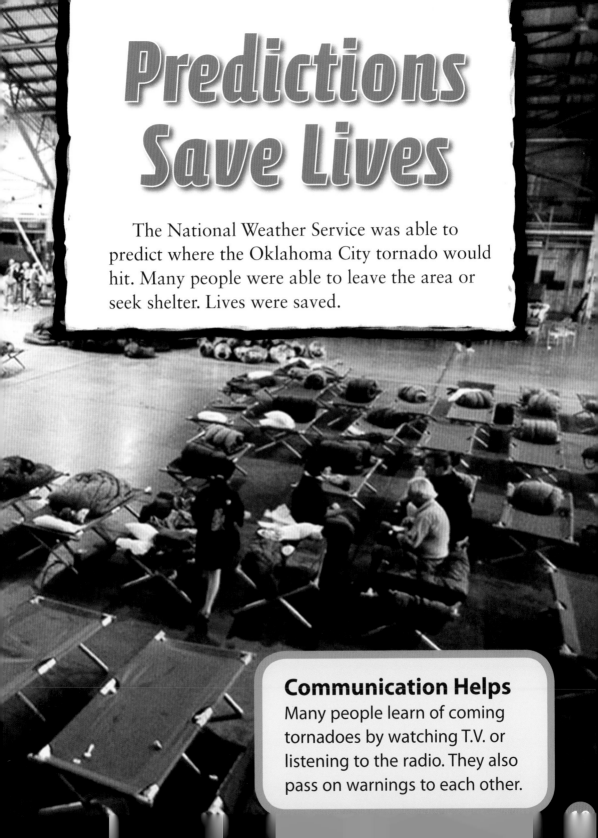

Predictions Save Lives

The National Weather Service was able to predict where the Oklahoma City tornado would hit. Many people were able to leave the area or seek shelter. Lives were saved.

Communication Helps

Many people learn of coming tornadoes by watching T.V. or listening to the radio. They also pass on warnings to each other.

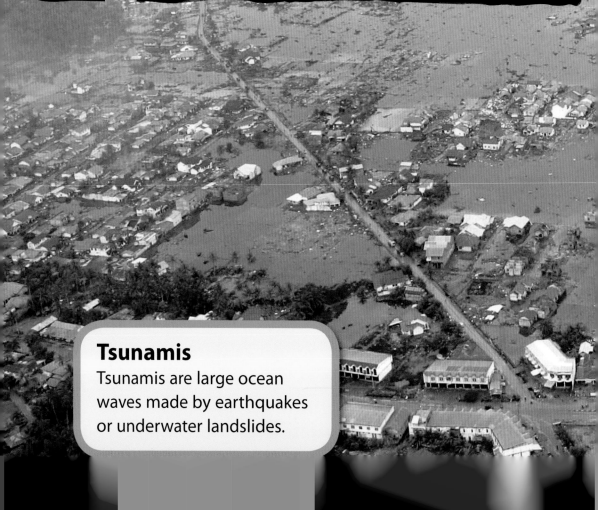

The 2004 Asian Tsunami

Early predictions can save lives. But on December 26, 2004, a huge, undersea earthquake happened without warning. It **occurred** off the west coast of Sumatra (soo-MAH-truh), in Indonesia (in-duh-NEE-zhuh).

Tsunamis
Tsunamis are large ocean waves made by earthquakes or underwater landslides.

A Tsunami Is Formed

The earthquake formed huge waves that spread across the Indian Ocean. A giant tsunami (soo-NAHM-ee) reached the shores of many countries. It caused one of the worst natural disasters in modern history.

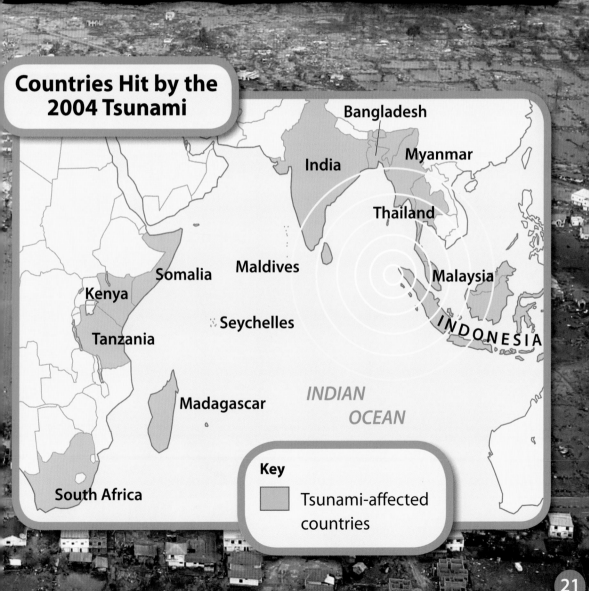

Countries Hit by the 2004 Tsunami

Bangladesh

India

Myanmar

Thailand

Somalia

Maldives

Malaysia

Kenya

Seychelles

INDONESIA

Tanzania

Madagascar

INDIAN OCEAN

South Africa

Key

Tsunami-affected countries

The Tsunami Hits

Fifteen countries were hit by the tsunami. The worst hit countries were Indonesia, Sri Lanka (shree-LAHN-kuh), Thailand (TIE-land), and India. Over 200,000 people lost their lives.

Many of these people lived in fishing villages. The villages were close to the shore. Some coastal towns were **tourist** spots. Many tourists lost their lives when the waves struck.

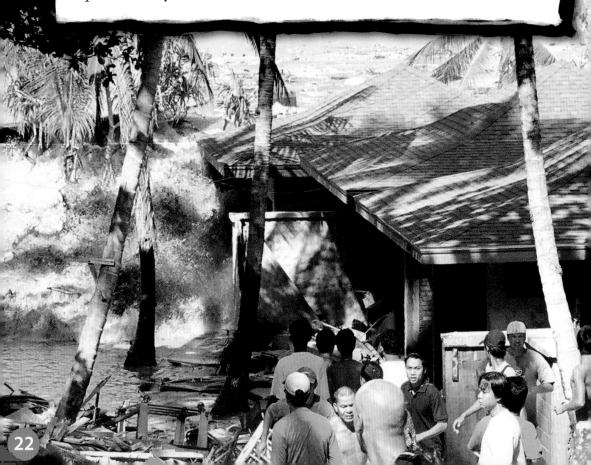

There were several hours between the earthquake and the tsunami hitting land. But most people were taken by surprise. This is because there were no tsunami warning systems in the Indian Ocean.

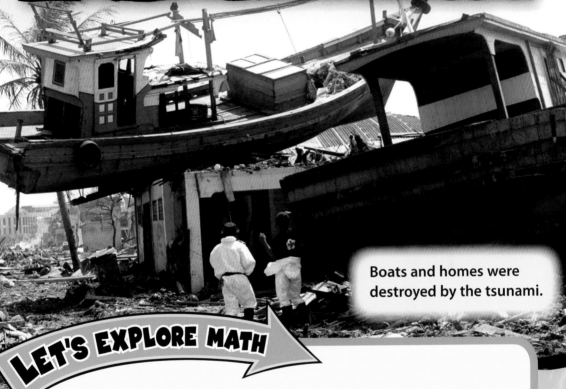

Boats and homes were destroyed by the tsunami.

LET'S EXPLORE MATH

Earthquakes cause **vibrations** in the earth. These vibrations are measured on a scale called the Richter (RIK-tuhr) scale. An earthquake measuring 6.0 or greater can cause serious damage.

Use the table to estimate the total number of earthquakes from 2003 to 2007.

Number of Earthquakes Worldwide Greater than 7.0

Year	Earthquakes > 7.0
2007	14
2006	11
2005	11
2004	16
2003	15

A Warning System

After the Asian tsunami, an Indian Ocean Tsunami Warning System was needed. Many countries from around the world worked together to create the system. By late June 2006, the system was being used.

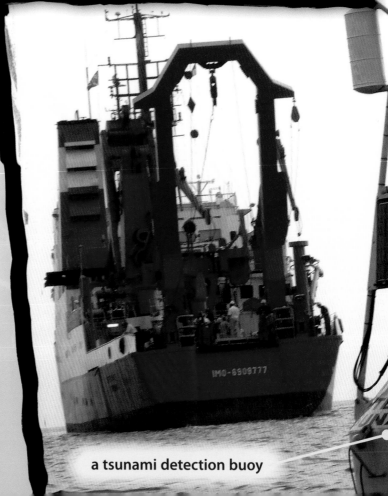

a tsunami detection buoy

Twenty-five data stations are part of the Indian Ocean Tsunami Warning System. These stations collect data when earthquakes happen. Then, the stations send this data to tsunami information centers.

Millions of tiny earthquakes occur in the world each year. Many occur in **remote** areas. They also measure very low on the Richter scale.

This table shows the yearly number of earthquakes in the United States over 5 years.

Earthquakes in the United States

Year	2003	2004	2005	2006	2007
Number of Earthquakes	2,946	3,550	3,685	2,783	2,791

a. Round each number to the nearest 1,000. Estimate the total number of earthquakes.

b. Round each number to the nearest 100. Estimate the total number of earthquakes.

c. Compare the 2 estimates. Which do you think is more accurate?

Spreading the Warning

Lives will be saved only if the tsunami warnings reach people. Some people do not have radios, televisions, or telephones. Governments must find the best ways of quickly letting people know if a tsunami is coming.

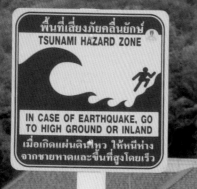

TSUNAMI HAZARD ZONE

IN CASE OF EARTHQUAKE, GO TO HIGH GROUND OR INLAND

Evacuation route Map

YOU ARE HERE

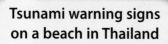

Tsunami warning signs on a beach in Thailand

Saving Lives

We cannot stop natural disasters. But we can collect more data about them. The data will help us predict why, where, and when these disasters may happen. These predictions can help save lives.

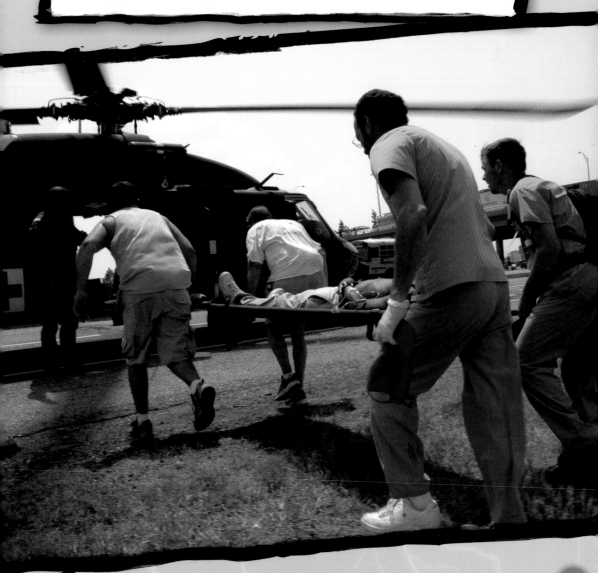

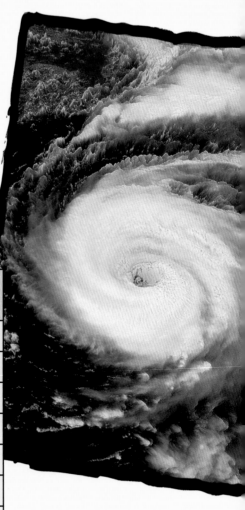

Windyville Evacuated!

Scientists have been studying the number of hurricanes in Windyville over the past 8 years. They have also collected data on the number of people that needed evacuation. This table shows their data.

Hurricane Evacuations

Year	Hurricanes	People Evacuated
2007	5	1,195
2006	3	823
2005	4	1,072
2004	2	586
2003	0	0
2002	1	217
2001	2	503
2000	1	195

Solve It!

Estimate how many people were evacuated:

a. from 2000 to 2003.

b. from 2004 to 2007.

c. over the 8 years.

Use the steps below to help you solve these problems.

Step 1: Round to the nearest 100 the number of people evacuated each year.

Step 2: Add the numbers to find the total number of people evacuated from 2000 to 2003.

Step 3: Add the numbers to find the total number of people evacuated from 2004 to 2007.

Step 4: Add your answers together to work out the answer to **c.**

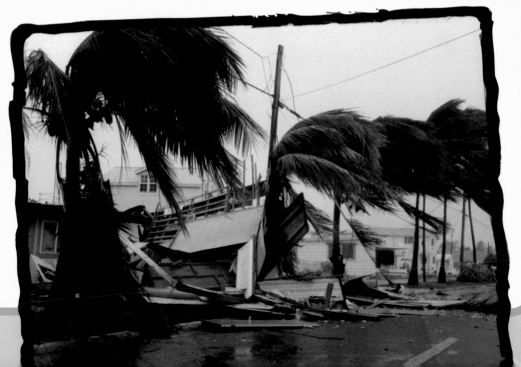

Glossary

estimate—to make a rough calculation or guess

evacuated—removed to a safe place

damage—harm done to a person or thing

front—where two masses of air meet each other

levees—banks or walls built to protect land from possible floodwater

meteorologists—people who study climate and weather

natural disasters—events occurring in nature, such as tornadoes or floods, that cause huge amounts of damage

occurred—happened

predicted—to have said in advance that something will happen

radar— an instrument that sends out radio waves as a way of finding objects

remote—far away, out of the way from other places

rotate—to turn or spin like a wheel

severely—very badly

shelter—a place that provides protection, covering, or safety

storm surges—water pushed toward shore by the force of a storm

tornado spotters—people trained to observe and confirm severe weather events, such as tornadoes

tourist—someone who travels for sightseeing or pleasure

tropical—relating to or occurring in the tropics. Tropical places are hot and humid.

vehicles—cars, trucks, bikes, and other forms of transport for carrying people or goods

vibrations—shaking or throbbing movements

Index

earthquakes, 20–21, 23, 25

hurricane, 4, 5, 6–8, 9–10, 11

Hurricane Katrina, 5, 6–8, 9–10, 11

Indian Ocean, 21, 23, 24–25

Indian Ocean Tsunami Warning System, 24–25

levees, 6, 9

Louisiana Superdome, 7–8, 10

meteorologists, 14, 16, 18

National Weather Service, 7, 11, 19

New Orleans, 5, 6, 7, 9, 11

Oklahoma, 12, 13, 16, 17–18, 19

rescue, 8, 10

Rocky Mountains, 13, 15

storm, 4, 5

storm surge, 6, 9

Tornado Alley, 13, 15

tornadoes, 12, 13–16, 17–19

tsunami, 20–21, 22–23, 24–25, 26

thunderstorms, 14–16

United States, 4, 13, 18, 25

Answer Key

Let's Explore Math

Page 6:
30 ft. + 20 ft. + 15 ft. + 20 ft. + 25 ft. = 110 ft.
110 ft. ÷ 5 hurricanes = 22 ft.
Average height of storm surges in feet:
22 ft.
10 m + 5 m + 5 m + 5 m + 10 m = 35 m
35 m ÷ 5 hurricanes = 7 m
Average height of storm surges in meters:
7 m

Page 14:
a. 15 ÷ 5 = 3 miles
b. 21 ÷ 3 = 7 kilometers

Page 18:
a.

Month	2007	2006	2005
January	20	50	30
February	50	10	10
March	170	150	60
April	170	250	130
May	250	140	120
June	130	120	320
July	70	70	140
August	70	80	120
September	50	80	130
October	90	80	20
November	10	40	150
December	20	40	30

b. Approximate number of tornadoes:
2007 = 1,100; 2006 = 1,110; 2005 = 1,260
c. Answers will vary.

Page 23:
An estimated total number of 70 earthquakes

Page 25:
a. 3,000 + 4,000 + 4,000 + 3,000 + 3,000
= 17,000 earthquakes
b. 2,900 + 3,600 + 3,700 + 2,800 + 2,800
= 15,800 earthquakes
c. Answers may vary. Rounding to the nearest 100 is more accurate than rounding to the nearest 1,000 because the total is closer to the actual amount.

Problem-Solving Activity

Step 1:

Year	Hurricanes	People Evacuated
2007	5	1,200
2006	3	800
2005	4	1,100
2004	2	600
2003	0	0
2002	1	200
2001	2	500
2000	1	200

a. Approximately 900 people were evacuated from 2000 to 2003.
b. Approximately 3,700 people were evacuated from 2004 to 2007.
c. Approximately 4,600 people were evacuated over the 8 years.

32